We Like to Move

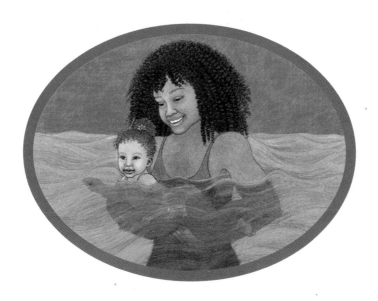

We Like to Move
EXERCISE IS FUN

E L Y S E A P R I L
WITH REGINA SARA RYAN

Illustrations by Diane Iverson

HOHM PRESS
Prescott, Arizona

Cover design: Kim Johansen
Book layout and design: Tori Bushert

Library of Congress Cataloging in Publication Data:

April, Elyse.
We like to move / Elyse April with Regina Sara Ryan ; illustrations by Diane Iverson.
p. cm.
Summary: Rhyming text and illustrations present activities that are enjoyable for all ages, including climbing, swimming, bowling and dancing.
ISBN 1-890772-60-7 (pbk. : alk. paper)
[1. Motion--Fiction. 2. Play--Fiction. 3. Stories in rhyme.] I. Ryan, Regina Sara. II. Iverson, Diane, ill. III. Title.
PZ8.3.A568We 2006
[E]--dc22
 2006011386

HOHM PRESS
P.O. Box 2501
Prescott, AZ 86302
800-381-2700
http://www.hohmpress.com

This book was printed in China.

10 09 08 07 06 5 4 3 2 1

Cover Illustration: Diane Iverson

A WORD TO PARENTS, FAMILY AND FRIENDS
from Regina Sara Ryan, coauthor of the *Wellness Workbook*

It is never too late or too early to start moving with joy. Whether we are young or old, overweight or underweight, or physically challenged in some way, we can always find simple ways to join in the dance of life. Everybody can and should move more, just for the fun of it!

Movement and exercise are vital for health and wellness, both for our children and ourselves. We breathe better and deeper when we move; our blood gets more life-giving oxygen when we exercise and play with vigor. We strengthen our heart and lungs. We build lean muscles. We balance our weight and our brain chemistry, which helps us to feel happier and better about ourselves…the list of advantages goes on and on.

This small book is designed to help us all remember that exercise and movement is fun and always available to us. We don't need fancy machines, sports equipment or special programs to begin. The joy and health benefits of exercise and movement can start with walking (or running) across an open space, climbing stairs with a bounce in our steps, dancing in the kitchen, or jumping around the room. The important thing is to get up and play.

Read this book with your children. Ask them to show you how they jump or roll or run…and give yourself and them the gift of joining in their play.

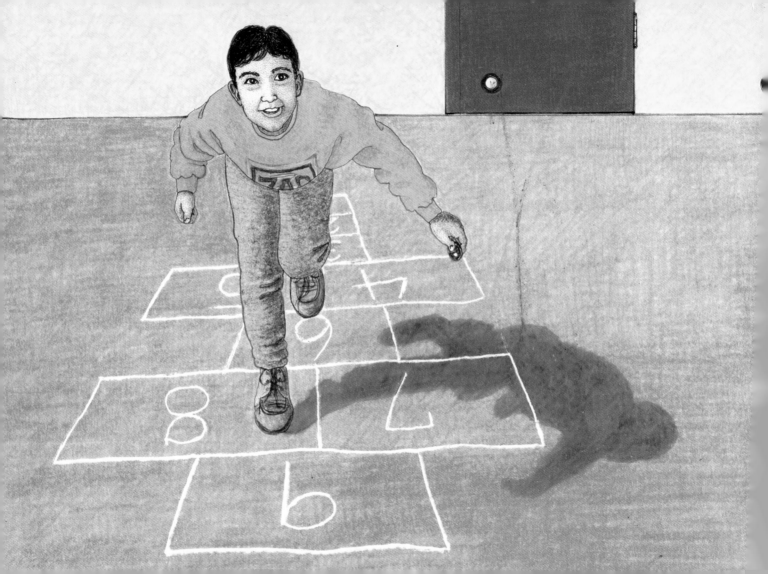

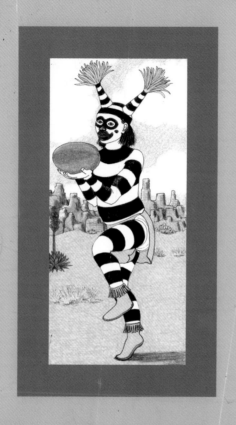

We like to hop.

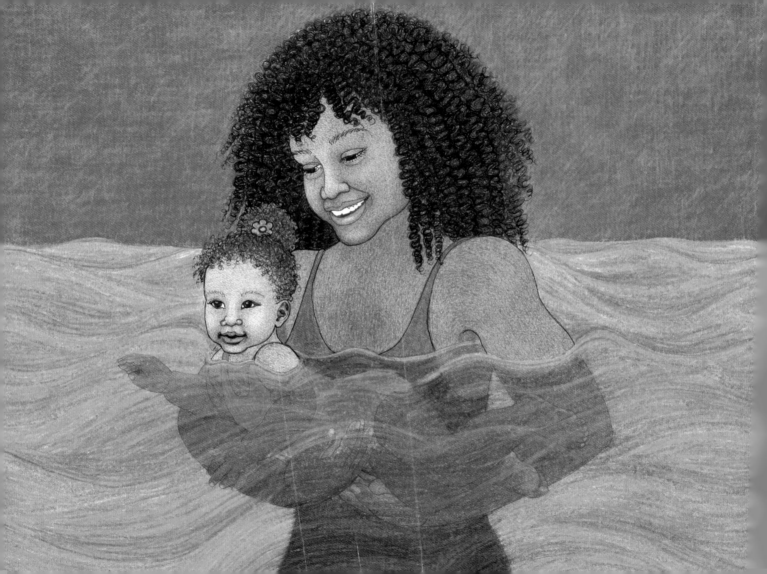

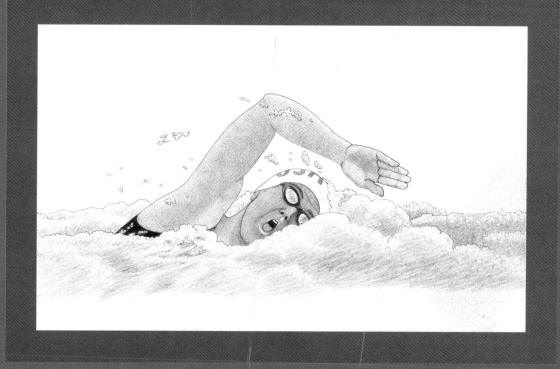

We like to swim.

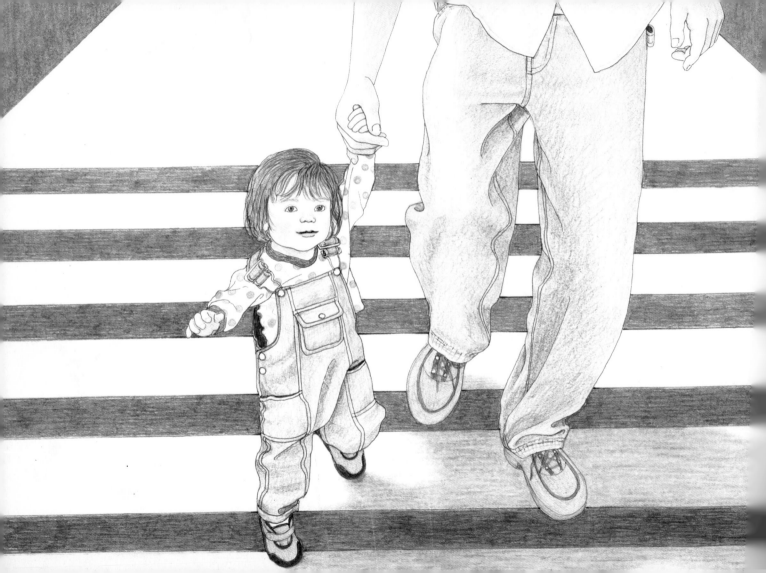

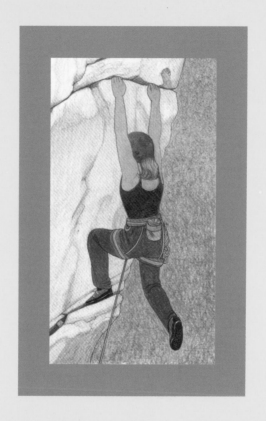

We like to climb.

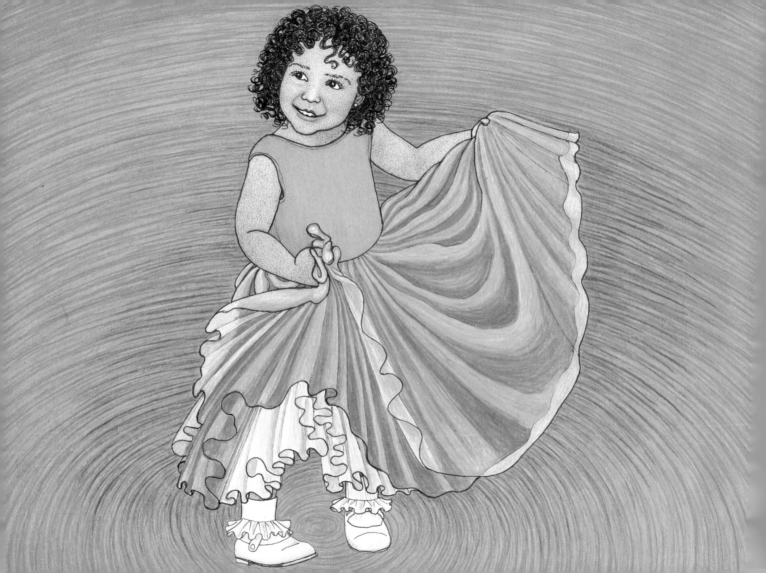

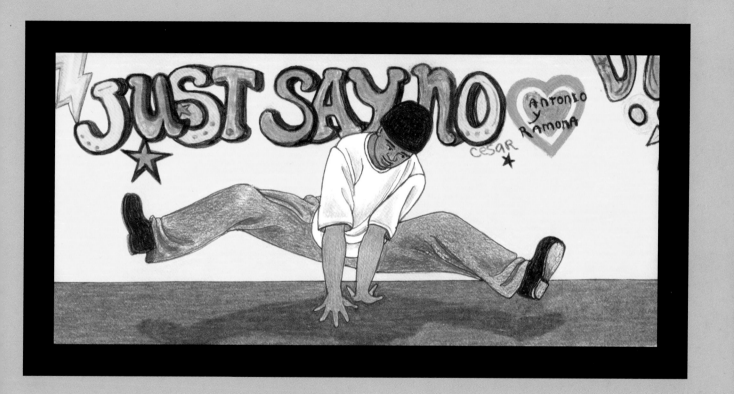

We like to spin.

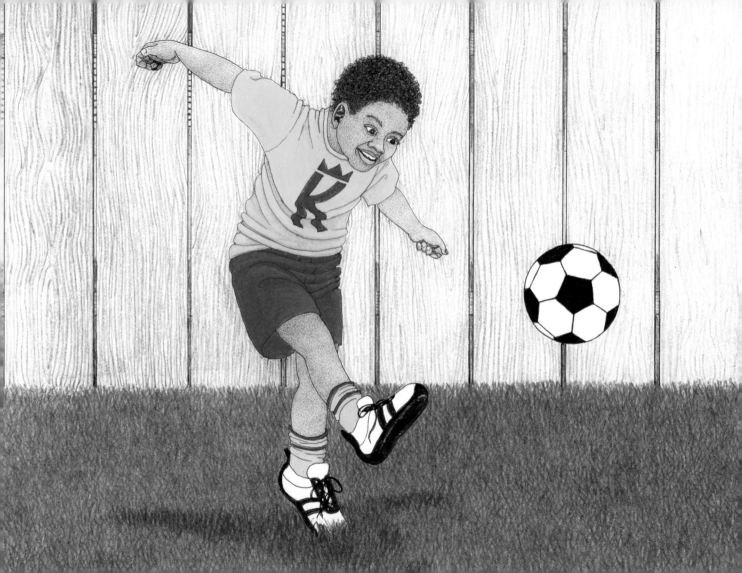

We like to kick.

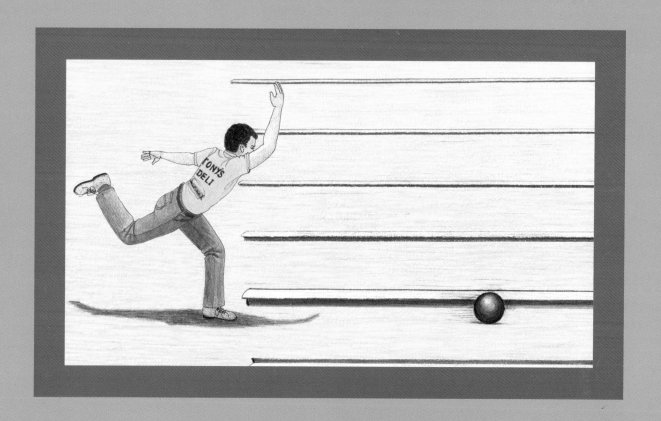

We like to bowl.

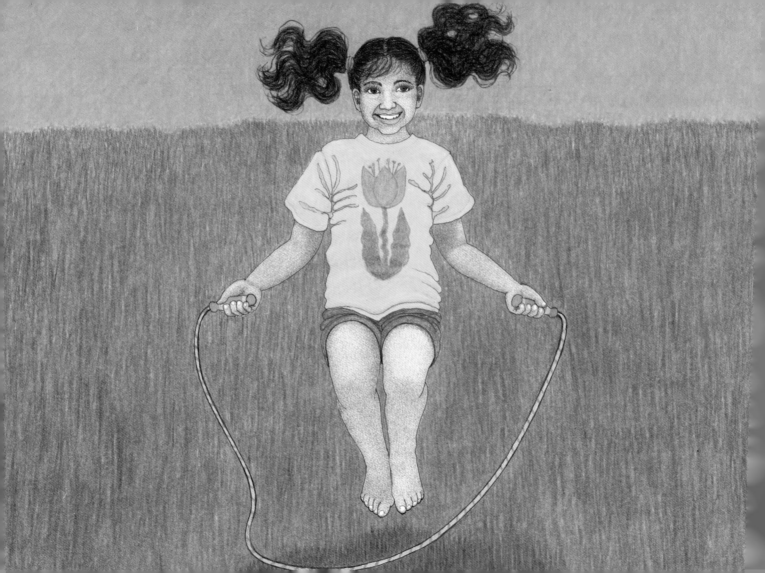

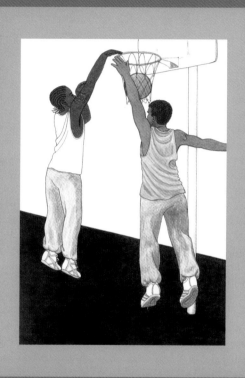

We like to jump.

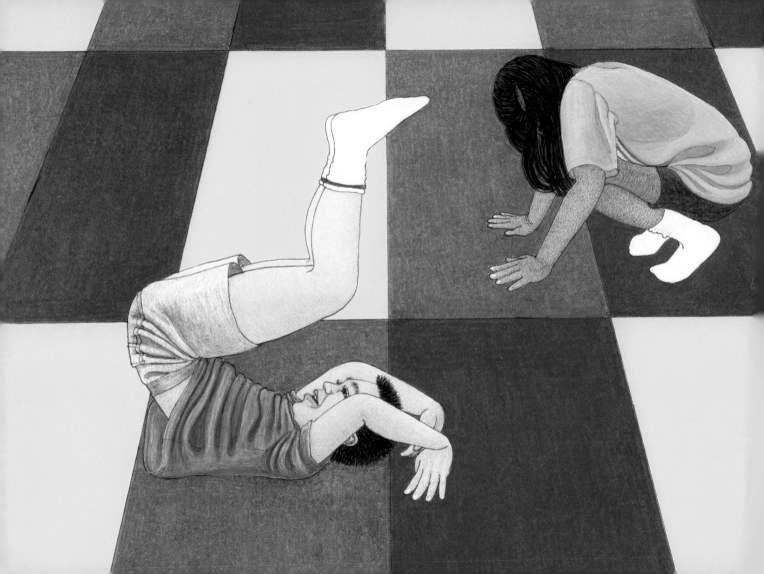

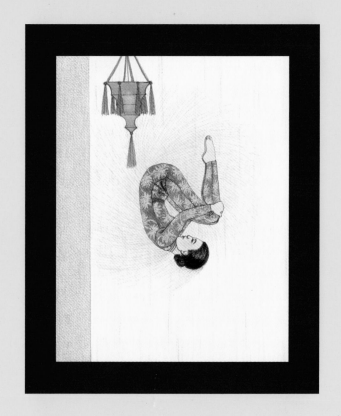

We like to roll.

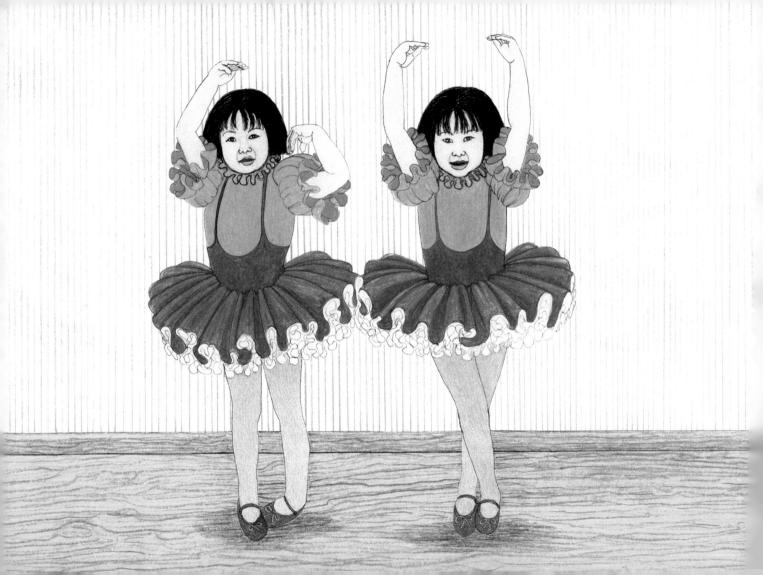

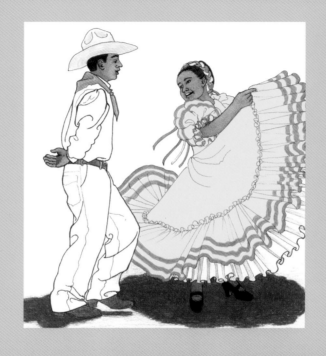

We like to dance.

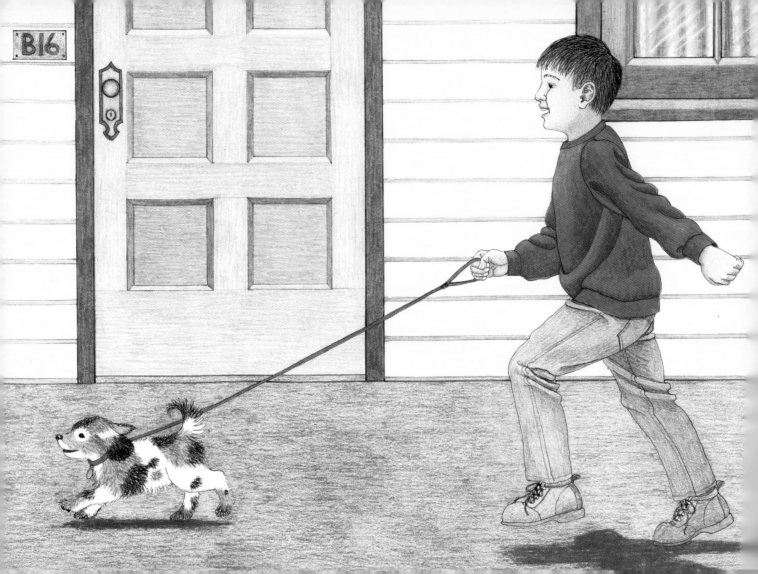

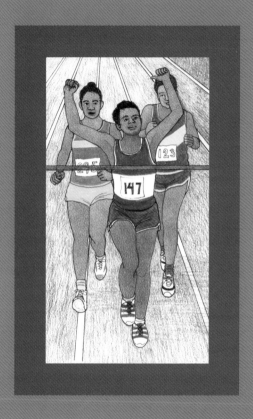

We like to run.

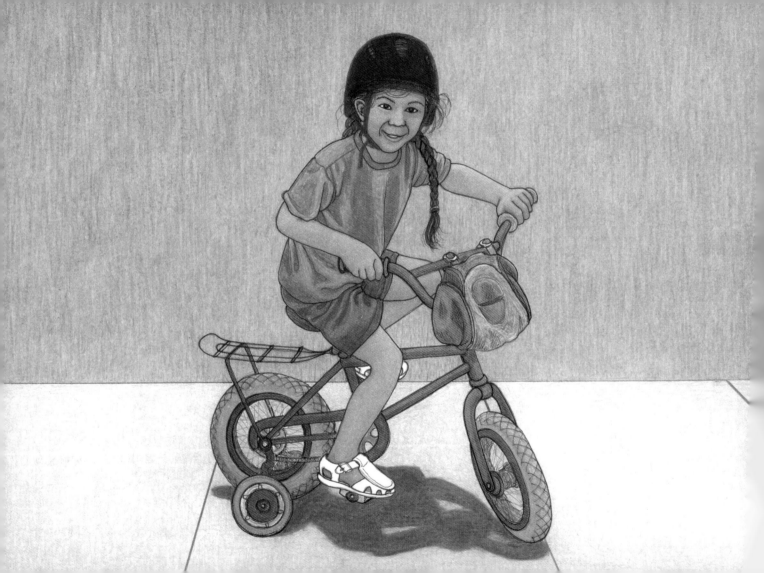

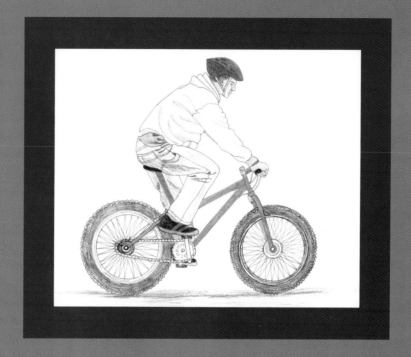

We like riding bikes.
It's healthy and fun.

We like to move
from birth to old age.

We like to move
right off the page..

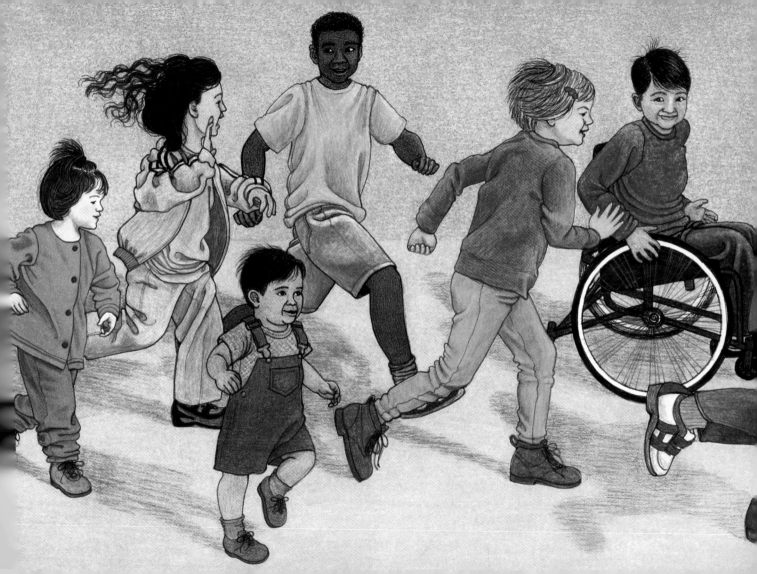

Other Titles of Interest from Hohm Press

WE LIKE TO NURSE
By Chia Martin
Illustrations by Shukyo Lin Rainey

This unique children's picture book supports the case for breastfeeding, as it honors the mother-child relationship, reminding young children and mothers alike of their deep feelings for the bond created by nursing. Captivating and colorful illustrations present mother animals nursing their young. The text is simple and warmly encouraging.

"A delightful way to remind the very young of our species' natural heritage as well as our deep kinship with other mammals." — **Jean Liedloff,** author *Continuum Concept*.

Paper, 36 pages, 16 full-color illustrations, $9.95 ISBN: 0-934252-45-9

SPANISH LANGUAGE VERSION: *Nos Gusta Amamantar*
ISBN: 1-890772-41-0

BREASTFEEDING: *Your Priceless Gift to Your Baby and Yourself*
by Regina Sara Ryan and Deborah Auletta, R.N.

In a short, easy-to-read format, this book pleads the case for breastfeeding as the healthiest option for both baby and mom. With gorgeous photos and 20 compelling reasons why breastfeeding is best, this book summarizes current research about the disease-protective and nurturing substances that breast milk alone supplies. It also stresses the deep physical-emotional bond that breastfeeding establishes between mother and child.

"Great book for encouraging more moms to breastfeed."
 — **Peggy O'Mara,** editor and publisher, *Mothering Magazine*.

Paper, 64 pages, 22 color and b&w photos, $9.95 ISBN: 1-890772-48-8

Easy-Reader version, ISBN: 1-890772-59-3

SPANISH LANGUAGE VERSION:
Amamantar: El Regalo Más Preciado Para Tu Bebé Y Para Tí ISBN: 1-890772-57-7

To Order: 800-381-2700, or visit our website, www.hohmpress.com • **Special discounts for bulk orders.**